ANGELS AT THE ARNO

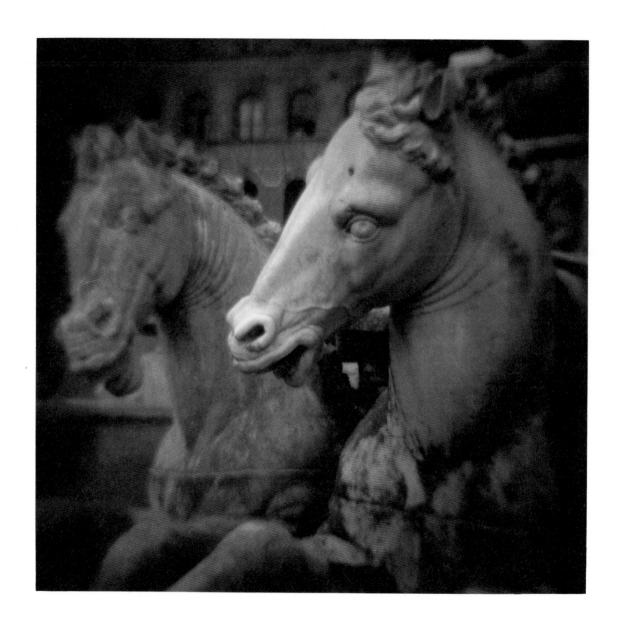

ANGELS AT THE ARNO

Photographs by

ERIC LINDBLOOM

With a Preface by Linda Pastan,
an Introduction by Ben Lifson,
and an Afterword by Italo Zannier

DAVID R. GODINE, PUBLISHER · BOSTON

ACKNOWLEDGMENTS

Fellowships from state and county arts councils arrived at propitious moments, assisting me in both the start and completion of this project, and are here acknowledged with gratitude. A Creative Artists Public Service (CAPS) Fellowship, funded by the New York State Council on the Arts, allowed me to make the first trip to Florence, and a Dutchess Art Fund / Individual Artists Fellowship, awarded by the Dutchess County Arts Council, came just as final preparations for the book were due.

On seeing the prints from the first trip, a number of friends offered clues to where in Florence I might journey next. I would like to thank them all, though I name only one: the painter Eleanor B. Daniels (1944-1990), whose knowledge of Florence cast a light on my path.

The good service of George Tatge, at the Archivi Alinari in Florence, and Lawrence P. Lewis, at the Center for Photography in Woodstock, New York, were also of great help in making this book.

E. L.

An Imago Mundi Book first published in 1994 by David R. Godine, Publisher, Inc.
Horticultural Hall, 300 Massachusetts Avenue, Boston, Massachusetts 02115

Library of Congress Cataloging-in-Publication Data
Lindbloom, Eric. 1934–
 Angels at the Arno/photographs by Eric Lindbloom: with a preface by
 Linda Pastan, an introduction by Ben Lifson, and an afterword by Italo Zannier.
 p. cm. (Imago mundi book)
 Photographs made in Florence between 1979 and 1987 with a Diana camera.
 1. Florence (Italy) – Pictorial works. I. Title. II. Series.
DG734.4.L56 1994 945'.510929'0222–dc20 93-50142 CIP

ISBN 0-87923-994-8
First edition. Printed in Italy.

CONTENTS

To Nancy,
angel beyond the darkroom door,

and Dan McCormack,
for the gift of the Dianas

Preface
BY LINDA PASTAN

Mary McCarthy, in The Stones Of Florence, wrote that "All great Florentine art, from Giotto through the quattrocento, has the faculty of amazing with its unexpected and absolute truthfulness. This faculty was once called Beauty." McCarthy was speaking of the Giottos, of the Brancacci Chapel and the Carmine. But in Eric Lindbloom's book of photographs we see that what she says is also true of quieter, more modest art, found here on the narrowest side street or tiniest garden, in a small funeral statue or on an offering box. This is an intimate Florence, a city whose often forbidding doors and windows are shown on such a human scale that we are invited in.

As if the camera knows that Florence is a city of blacks and whites and umbers, with only the darkest greens veining the marble, the darkest grays of car and Vespa smoke clouding the lungs, these photographs are not in color. And yet the hard-edged masculine aura of the city is somehow modulated for us into the mood, though not the fact, of sepia. In contrast to the muscular Davids that we usually see, there are smooth-limbed angels everywhere, womanly angels who radiate warmth, even domesticity, and a kind of informed innocence. There is a flower girl and a Ceres with her sheaf of wheat, their expressions beguiling and each touched with a genuine sweetness. Even the lion from the Piazza della Signoria has a ball under its paw that could be a child's soccer ball it is simply playing with.

As I looked at these pictures, I could imagine I heard the flutter of wings, for not only are there angels everywhere, there are winged horses, winged cherubs – even an hourglass has wings – and there are bicycles whose wings we half expect to see. For we are at

the interface between the human and the angelic, a place where transformations take place, where, though the shape and feel of stone is perfectly reflected, stone becomes more than itself, softer than simply itself; as with the Word it is somehow made flesh. Is the mourning figure near a vase of dried grasses a human being or a statue? I'm still not sure. Are the curtains at a window made of cloth or stone? Their folds have the texture of permanence, just as the pedestal in the Boboli Gardens has the texture of the bark on the row of trees, each straight as a column, behind it.

These photographs have a timelessness that almost makes us believe they could have been taken in the Renaissance. At the very least, we seem to know what the photographers of that time might have done had they existed. For the pictures here are so sensuous and at the same time so austere that they call to mind the music of Monteverdi or of the Florentine Luca Marenzio, writer of motets for the marriage of Grand Duke Ferdinand of Florence. The noise I still remember that went on all night outside my hotel window, double-paned as it was, is almost entirely muted; and if I am lucky enough to return to Florence soon, it will be the sound of harps or of harpsichords I will hope to hear.

"I am tired of angels," I wrote in a poem recently, "Of how their great wings / rustle open the way a curtain opens / on a play I have no wish to see . . ." Eric Lindbloom, in this book of photographs, has somehow reinvented angels for me, woken me up again to their power and delicacy. For a short time, the time it took me to look through this book, and then to look and look again, Florence was transformed from a city of blaring car horns and leather vendors, impressive piazzas and forbidding, if extraordinary, facades to a quiet place of small streets and courtyards, of homespun angels whose wings throw light and shadow over everything, even at high noon.

Introduction

BY BEN LIFSON

Here before me now is my picture, my map,
of a place and therefore of myself,
and much that never can be said adds to its reality for me,
just as much of its reality is based on my own shadows, my inventions.

M. F. K. Fisher, *Map of Another Town*, 1964

Eric Lindbloom woke up one day in Amsterdam in May, 1979 and convinced his wife and nine-year-old son that the family should leave immediately for Florence. Nothing had been farther from their minds; they were in Holland because Lindbloom had received a grant to photograph in northern Europe. Born and reared in Michigan and of Scandinavian descent, he thought he would naturally have something to say about the north. But by the end of that day, all three were on a train to Italy.

Both the trip and the work of art that resulted from it (after three subsequent visits) are in an artistic tradition that figures the journey as an existential adventure: at once the inheritance and a necessity of the human condition. The tradition begins with the Epic of *Gilgamesh* and is constantly being added to. Whether the journey is real or imaginary, a quest – for an object, a home, experience, knowledge, salvation – or merely wandering, and whether the vision is hopeful or desperate, underlying each journey is a complex belief, among whose tenets are: that the world, if left to its own devices, will continually surprise us and disclose wonders; that one must submit to the journey's terms as they

9

reveal themselves; that as long as you keep moving all is possible; and that once you are on the road you will discover unsuspected resources within yourself, and perhaps even the will and ability to change.

For Lindbloom, change preceded the decision to go south. When he went to Holland that spring he had left behind the 4×5 view camera he had used for ten years, and instead took only a few small hand cameras. Among these were three Dianas, a small, cheap plastic camera with a fixed shutter speed and three aperture settings: bright, partly cloudy, and overcast. The Diana is so poorly made that light leaks into the film chamber unless one covers all seams with black electrician's tape after each film change. This camera had been a brief fad among American photographers in the early 1970s. Lindbloom acquired his because of a few Diana pictures he had seen in an exhibition and its possibilities dogged him long after the fad had waned. In Florence, the Dianas were the only cameras that came out of his bags, and with them he made the most convincing body of work to come so far from this extremely limited instrument.

But one mustn't stress the camera too much. Like all good art, Lindbloom's account of Florence stems from his curiosity about and respect for his medium, for what his equipment can do, and for his subject.

For the viewer and the artist alike, guidebooks, maps, novels, and histories stand behind any artistic survey of a significant historical place like Florence. For the viewer, such accounts are to the work at hand what the Bible is to religious art, the public text; for the artist they are a jumping-off point and a challenge to his or her skill, originality, and power. But Lindbloom is an intuitive and lyrical artist, and just as he obeyed the impulse to abandon his project in northern Europe, so he seems to have treated his survey of Florence as a private and random journey

of exploration – both of the place and of himself, as if he were venturing into undiscovered areas of each. For example, he was trained in philosophy, which necessarily involved a knowledge of European history and of the revival of Platonism during the Italian Renaissance, much of which occurred in Florence. It is likely that he arrived there, as do many visitors, with a highly evolved personal map of the city already in his mind; its streets, churches, and public buildings at once monuments in his own history of art and sites of Italian political struggles, containing faint echoes of two centuries' worth of Renaissance talk. To such an artist with such an imaginary map, the guidebook is off the point. The important thing is to move through the imagined city led by curiosity, receptiveness, and impulse, perhaps even in a sort of trance, until the actual and imagined cities merge. The important thing is to be arrested by the principal sites of this poetic amalgam, which no guidebook can identify because the sites announce themselves randomly, according to chance qualities of light, stillness, and emptiness, the chance perspectives of wandering, and the subliminal operation of the creative process.

Intuitively, Lindbloom knew that in order to take such an unpremeditated journey successfully, one often must abandon long established habits of perception. This is implied, at least, by Lindbloom's using the crude Diana, whose imprecise lines and reduction of the tonal scale to black, white, and middle gray are worlds apart from the precise delineation and finely graded tonalities of the view camera. Also, the Diana is so rudimentary than even so basic a technical operation as taking a light meter reading is irrelevant, to say nothing of the painstaking and complicated adjustments the view camera requires with every shift of vantage point and framing. Even walking through the streets without a heavy, bulky camera case in hand and a tripod over one's shoulder and working

free of the attention from passersby that such equipment often attracts means learning a new kind of physical movement and patterns of response. Seen one way, suddenly to shed the view camera's encumbrances is to feel lighter than air and enormously supple. But considered in existential terms the shift can be as disorienting as being catapulted into a different century, with nothing to go on but sight and a belief that human beings are always essentially the same, that culture itself always arrives at the same forms.

Perhaps this is why Lindbloom's Florence seems at once so familiar and yet so strange. So empty for a center of commerce and tourism! Outside of time, as Linda Pastan suggests, but not in the eternal present of the guidebooks; rather, an historical present. In a guidebook, the significance of a principal sight is changeless: the Duomo *represents* such and such a stage of Renaissance architecture, *is* the place where Giuliano de' Medici was assassinated. The timelessness of Lindbloom's work is fictional, at once fanciful and imaginative. It gives the impression that for some unknowable reason the people of Florence left the city all at once. They left it as clean and orderly as possible, and they had put away as many objects as they could that would date their exodus, but left here and there certain artifacts of the late industrial age: a bicycle, a motor scooter, mass-produced lamps, etc. Or we can imagine Lindbloom working only at dawn and twilight, when everyone was asleep or preparing for sleep, and at a strange season when ordinary changes of weather had ceased and the sun was low in the sky all day, so little do light and shade change here and so much do the effects of each scene depend upon the play of this strange twilight. (What guidebook mentions weather, or tells us at what hour a specific statue or fresco is best seen, or speaks of the effects of light and shadow on a building's ornaments?)

All these fictions stem, of course, from the effects of Lindbloom's handling of a camera that renders everything in a dreamlike half-light. In fact, Lindbloom worked during bright daylight, the Diana being useless at any other time. And Florence was crowded, as usual.

Dreamlike, too, is the unpredictable and unsystematic path Lindbloom seems to have followed. This is also a consequence of his art, specifically the art of the photographic book: of how the sequencing of pictures transforms a life experience into an artistic world, a transformation Lindbloom has contemplated ever since his engagement with photography began in the study of books rather than of individual prints or of exhibitions. The intimacy of this book was also determined in part by his earliest beginnings, when photographs meant to Lindbloom small pictures in small books, seen at no more than arm's length. Considered thus, the work is a return to Lindbloom's artistic origins and, perhaps, to the freshness, curiosity, and immediacy of his first engagement with the medium.

But here curiosity propels and freshness is achieved in part by a mature handling of one of the Diana's most rigid constraints: the square frame, which almost invariably forces weak photographers to put the principal subject in the center of the picture. Lindbloom contends strongly against this force, creating compositions full of visual incident spread all across the frame. He yields to the center when it would appear mannered not to, but in such pictures the composition is always his own, not imposed by the frame. Sometimes the element that allows the composition to contend against the center is as slight and transitory as a shadow (Plate 8) or a dip in a row of leaves (Plate 7); sometimes it is at once so highly intentional but so natural that we hardly notice it, as in Lindbloom's placement of a horizon, either visible (Plates 6, 42) or implied (Plates 30, 31).

Elsewhere it is a vivid object, like a word scrawled on a wall, or a dramatic visual effect, like Lindbloom's variation of two horses' heads (Plate 17). A climactic moment of this contention against the center comes when Lindbloom composes trees, shrubs, and a wall around only an *implied* center (Plate 28). The contention is constant and strenuous, and with each successive picture it renews our curiosity about what we will discover when we turn the next page.

In other words, over the entire span of the book, Lindbloom's art provides the variety that is necessary if a work is to give lasting aesthetic pleasure and draw the viewer into its imaginary realm. The same activity of surface sustains our impression that the work comes from a journey of exploration rather than from the impulse to perform a set piece, for variation carries us along with Lindbloom step by revelatory and imaginary step. It does even more. It enhances the expression of a theme central to works of art that take other art objects as their subjects: the theme of the reinvention or recasting of the artwork in question. In the fictional world of Lindbloom's Florence, figures like the beautiful winged horse in the courtyard of the *Pitti Palace* and the struggling angel of the *Duomo Museum* (which brought ancient myth to the Renaissance and Eternity into the present) can seem to us to be alarmed by the mysterious exodus that they perhaps hasten to join. In this same fancy, the figure of Spring at the *Ponte S. Trinità* pauses to give a backward glance, a smiling child lingers to delight one last time in a garden's lush simplicity, and a kneeling figure says a sorrowful farewell to the city.

Leaving this fiction behind (for it is not the only object of Lindbloom's sensuous thought), in other photographs centuries-old garden statues and more recent architectural ornaments join with the ongoing processes of nature to form compositions and to imply allegories that neither their original makers

intended nor their original patrons saw. It is through visible effects and implied meanings like these that Lindbloom has created new works of art in their own right rather than photographic renderings of earlier works.

The liveliness of these statues is also due to the softness of the pictures idiom – again, a direct consequence of the camera: even making allowances for erosion, these stones cannot be both as soft and as plastic as they seem here. Also, Lindbloom's handling of the Diana's lines, of its rough blocking out of shapes, of its reduction of the tonal scale and of its tendency to render an object's mass rather than its surface, belongs to that branch of draftsmanship called the sketch. And as preparation for a more finished work or as an end in itself, the sketch has for centuries been understood as the artist's first grasping of the object's totality, and of his own first visual and emotional impressions of it. It is in reference to these impressions, I think as well as in reference to skill, that Eugène Delacroix used to tell young artists that only *after* they had learned to sketch a suicide leap between a seventh-story window and the pavement would they be able to attempt a set piece of public art. It is Lindbloom's sketching that creates the immediacy of his angels, goddesses, and horses, the motility of their facial expressions, the plasticity of all this stone. We are never lulled into thinking that here are anything but statues and stones; rather, we imagine that we see them in their first impact upon Lindbloom's consciousness. Moreover, his handling takes them out of the realm of stone and reimagines them as figures in drawing: out of the immutable realm of finished art and into the tentative world of the sketch; out of their original fictions and into his own. At this point, whatever has been said about them by art historians, critics, and theorists becomes irrelevant, for they confront us as newly imagined figures in newly created works.

In the same spirit, Lindbloom disregards hierarchical distinctions regarding the beauty and music of forms. Monuments of Renaissance sculpture and architecture, pieces of artisanal workmanship, graffiti, mass-produced architectural ornaments, and mass-produced objects such as Vespas, bicycles, and reproductions of paintings have equal place in this imaginative and lyrical exploration of Florentine art.

Beyond the pleasure of a sustained, mature, artistic effort, this book provides a strong argument for freedom: freedom from preconceptions, from the authoritarianism of received ideas and hierarchies; it offers the free encounter between a receptive, creative mind and a phenomenon that is formidable not only by virtue of its inherent beauty and historical meaning, but also by virtue of what we tend to think of as the indelible stamp other minds have left upon it. And together with our knowledge of how this work originated, it also argues for belief in the self and in the journey, and sustains the central meaning of its tradition – namely, that simply by setting out, without map, itinerary, or goal, we might discover aspects of the self and of the world not otherwise accessible to us: a world in which the most familiar objects become new, a self whose every stop is adventurous, so that the map we leave behind at once describes both the place we reached and the mind that risked itself on the way.

THE PLATES

"Simplicity is not a goal in art,
but one arrives at simplicity
in spite of oneself…"

CONSTANTIN BRANCUSI

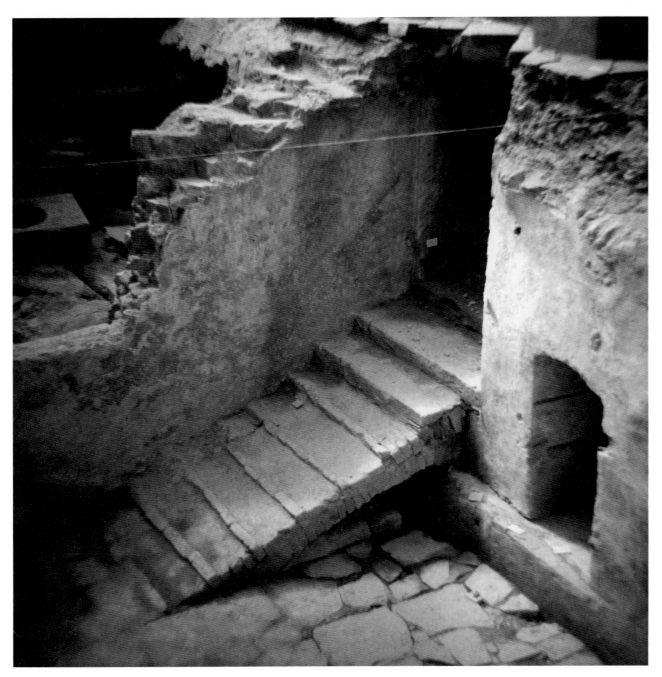

1. Piazza della Signoria

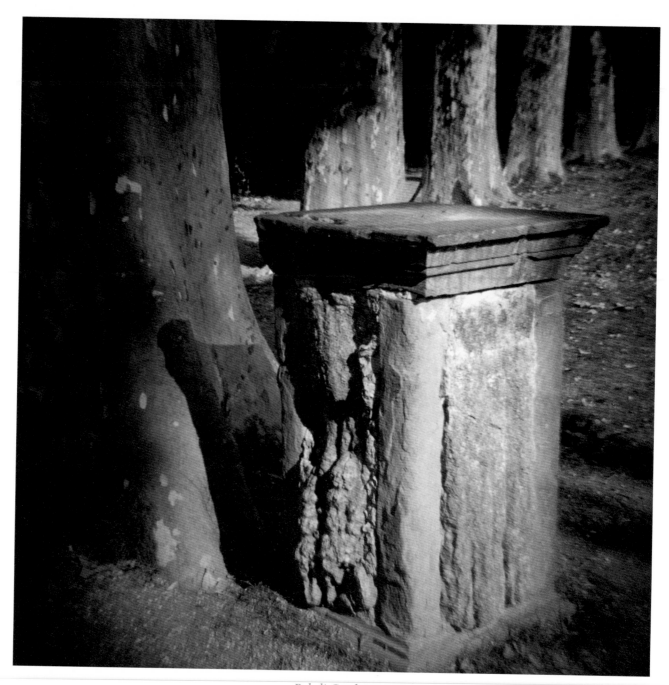

2. Boboli Gardens

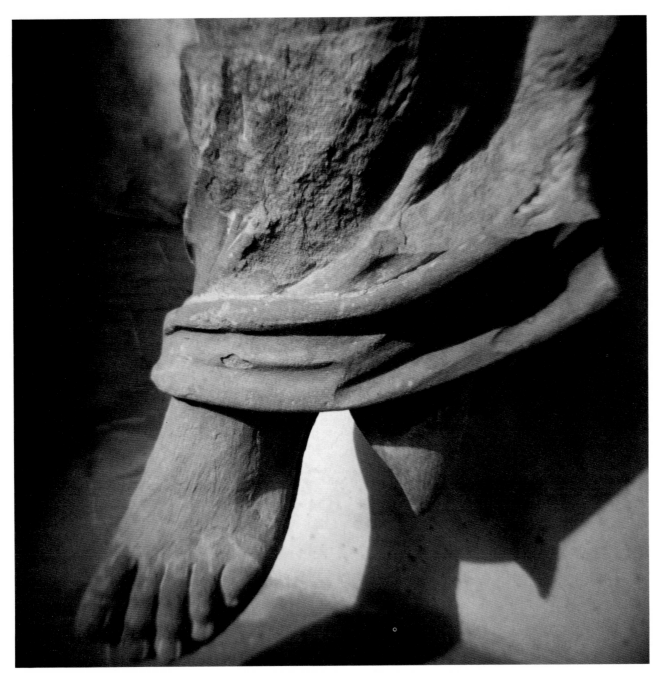

3. Topography Museum

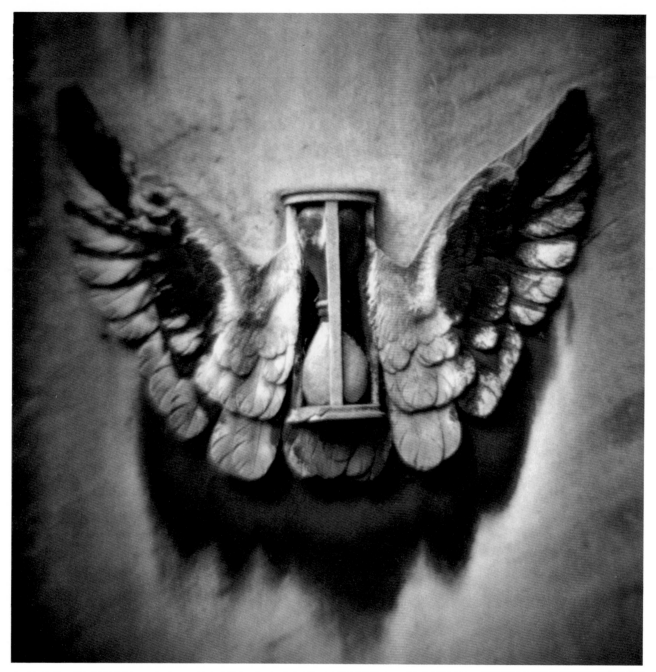

4. English Cemetery

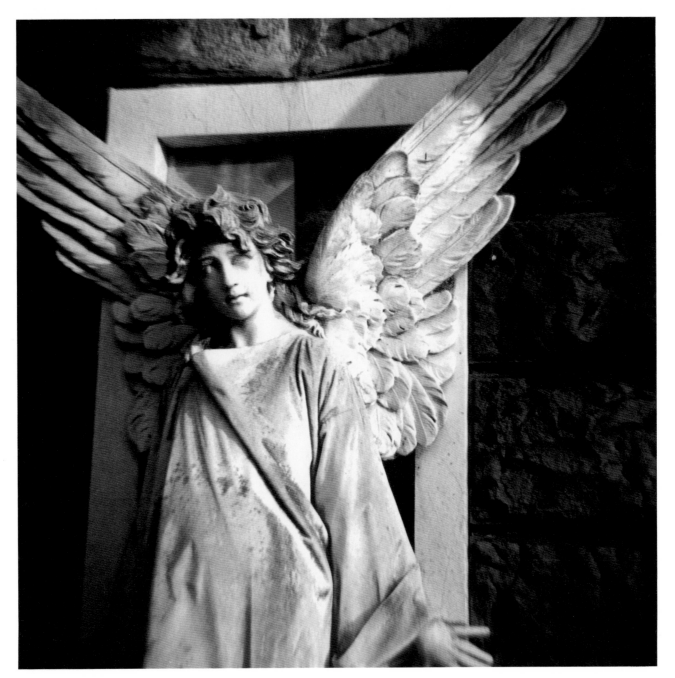

5. S. Miniato

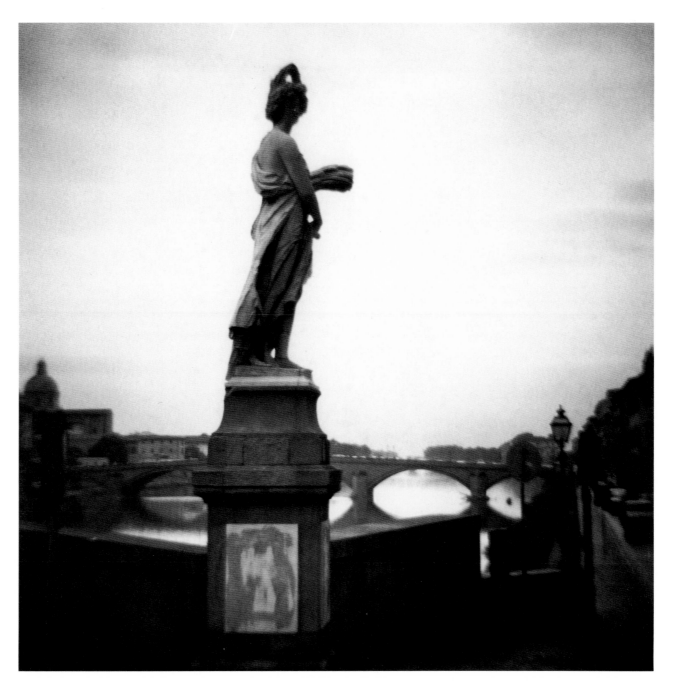

6. Ponte S. Trinità

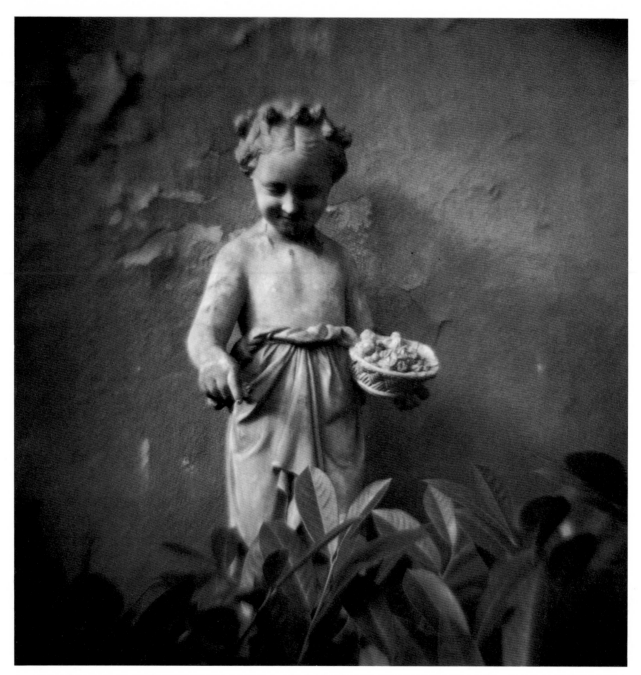

7. Hotel Berchielli

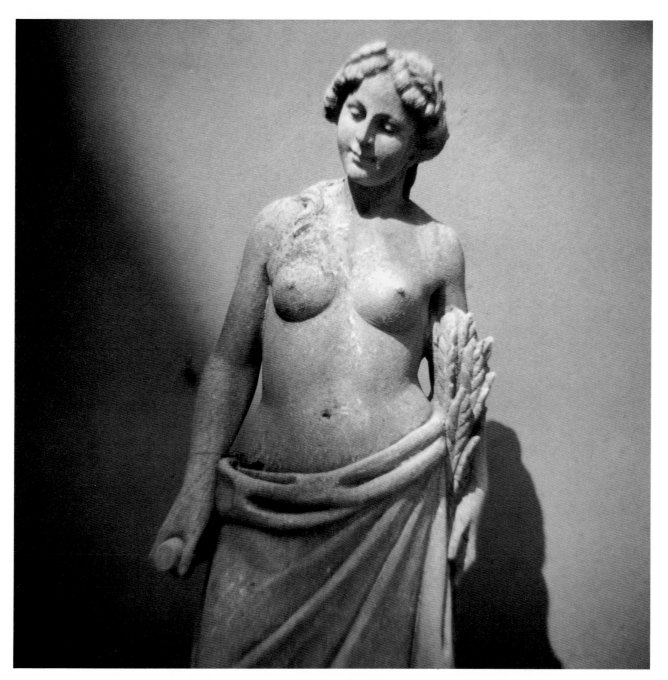

8. Via Magliabechi

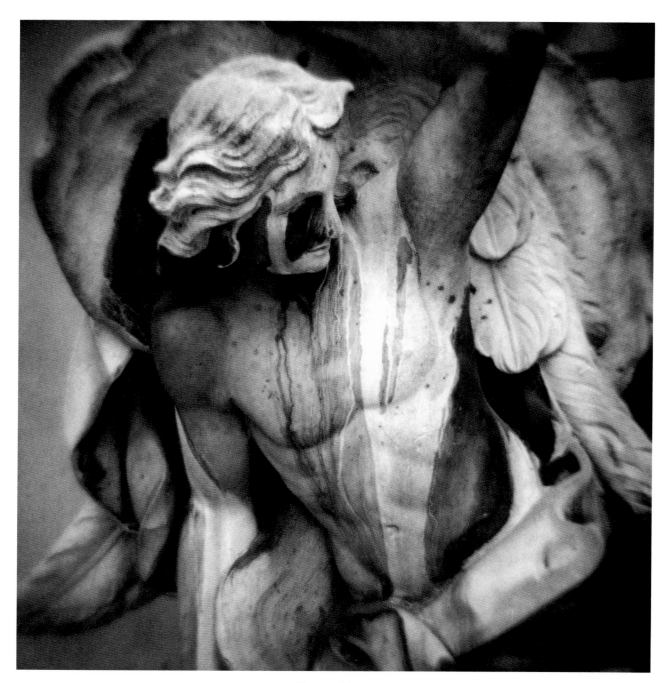

9. Duomo Museum

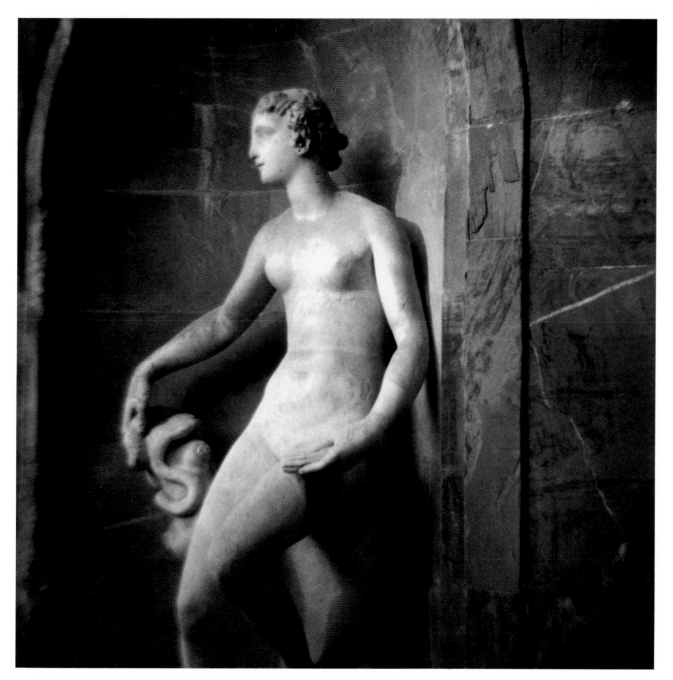

10. *Grotta Grande*

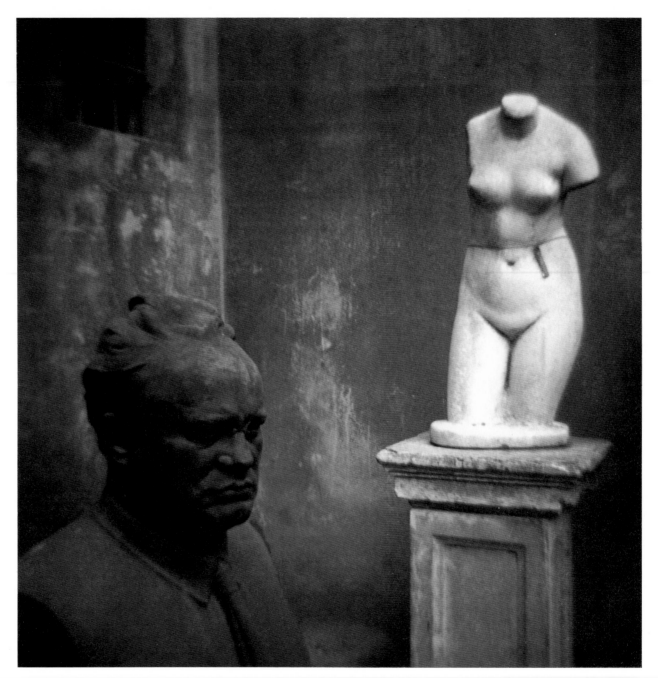

11. *Via Magliabechi*

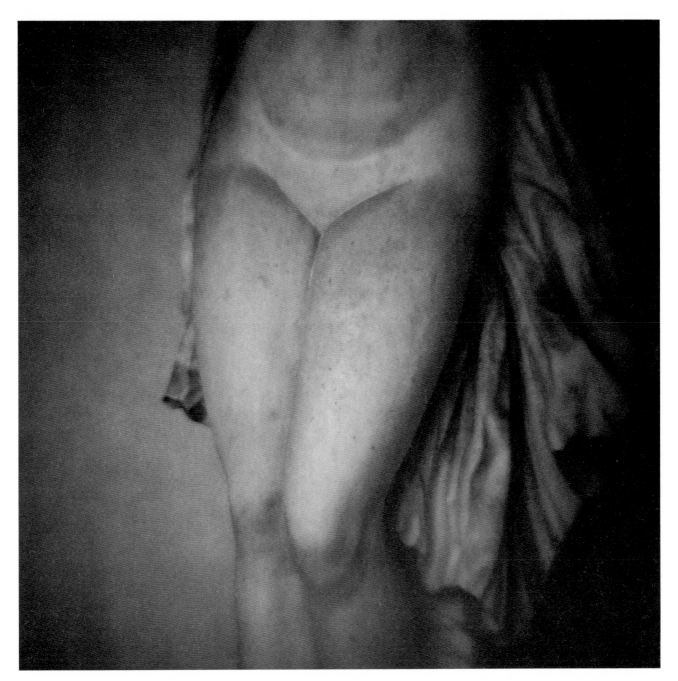

12. Bargello

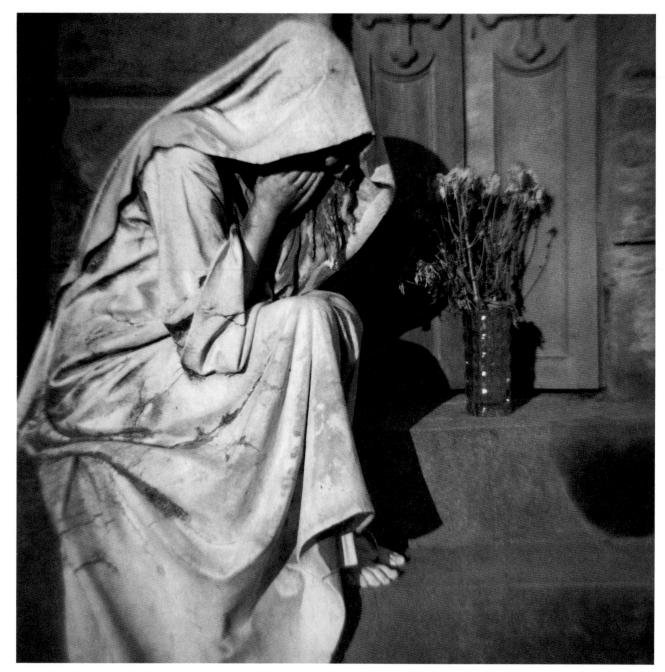

13. S. Miniato

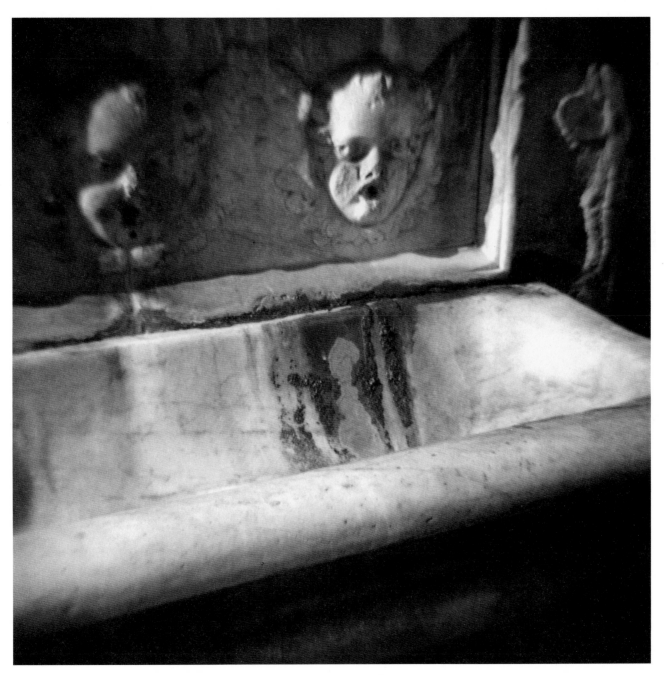

14. S. Lorenzo Market

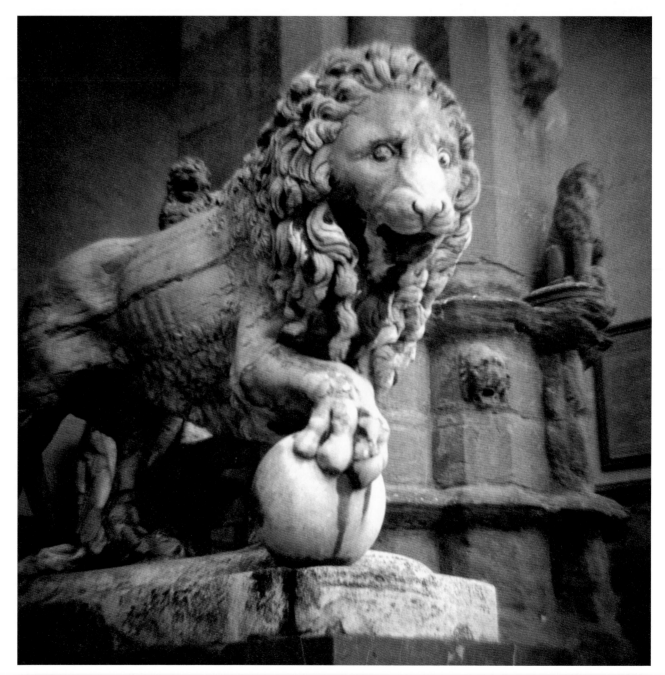

15. *Loggia dei Lanzi*

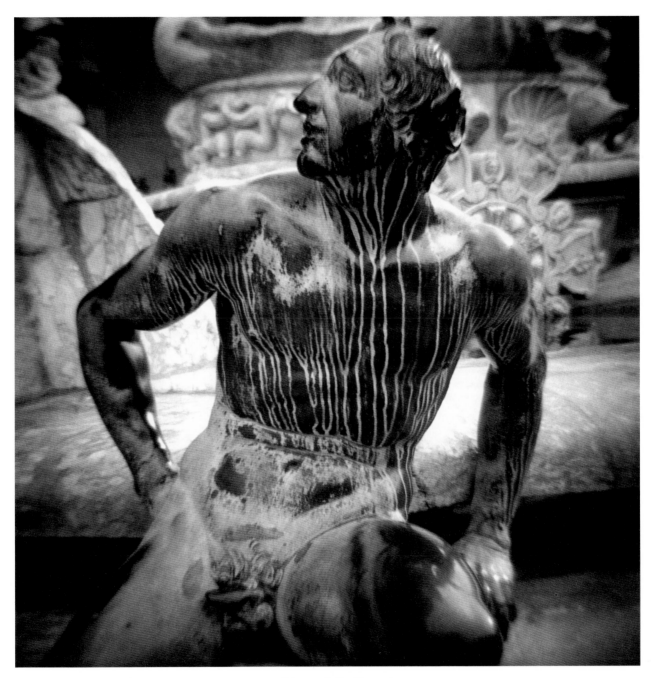

16. *Piazza della Signoria*

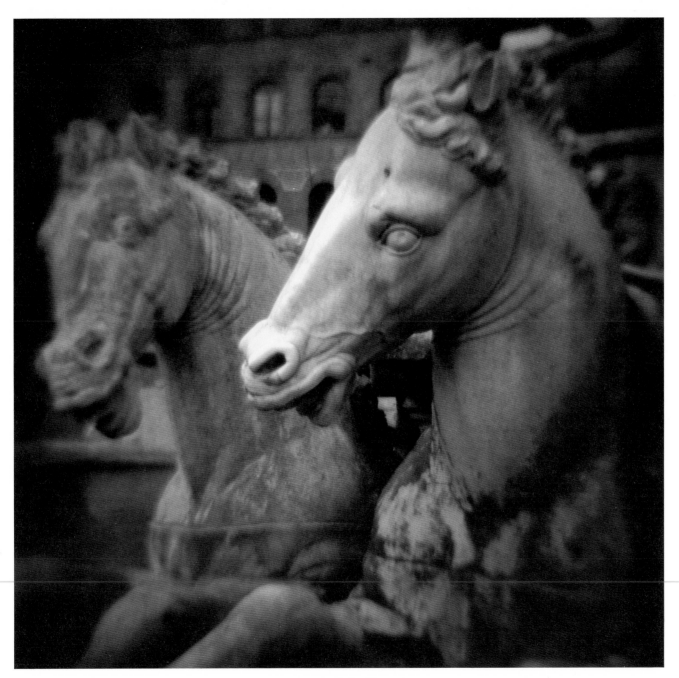

17. *Piazza della Signoria*

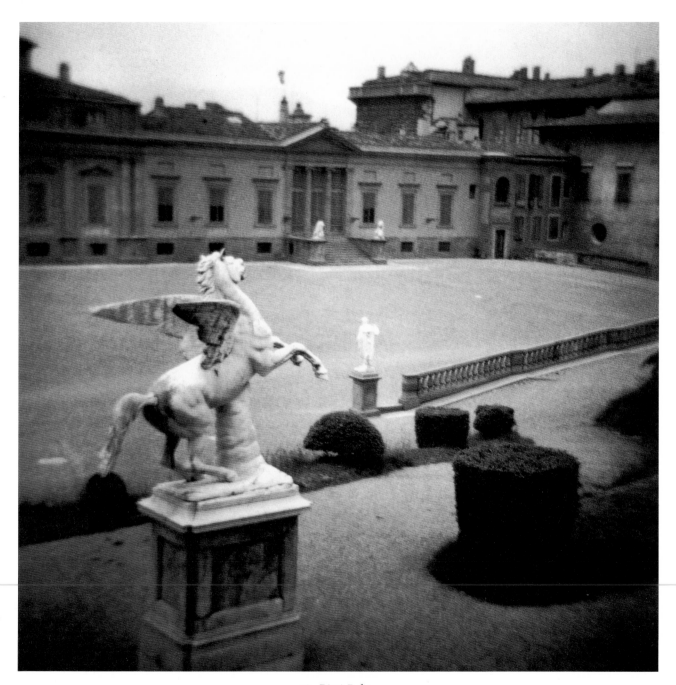

18. Pitti Palace

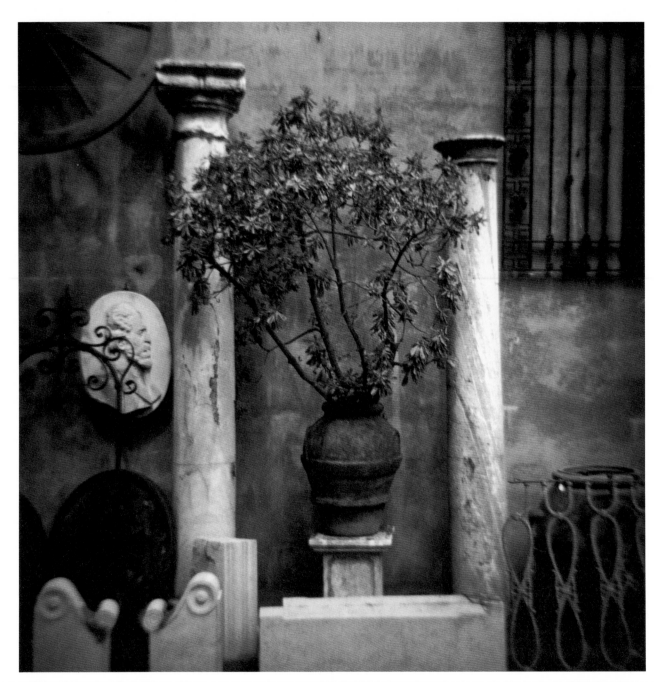

19. Via Magliabechi

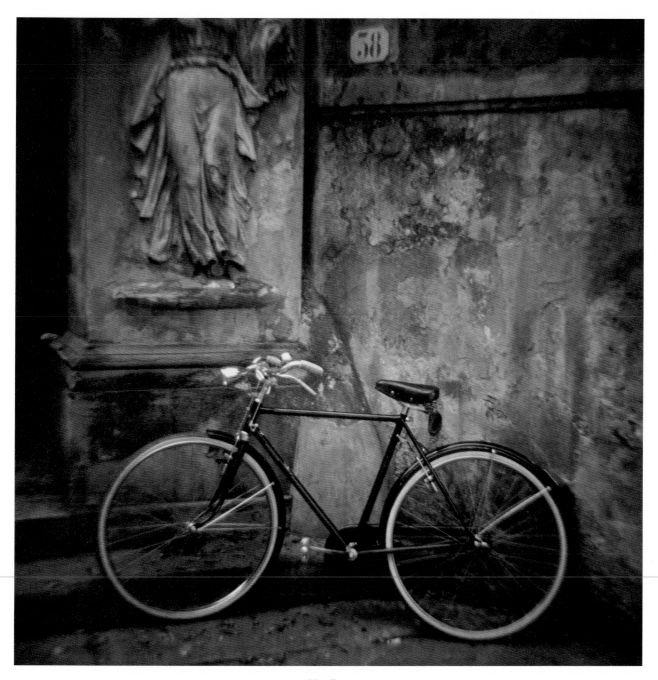

20. *Via Romana*

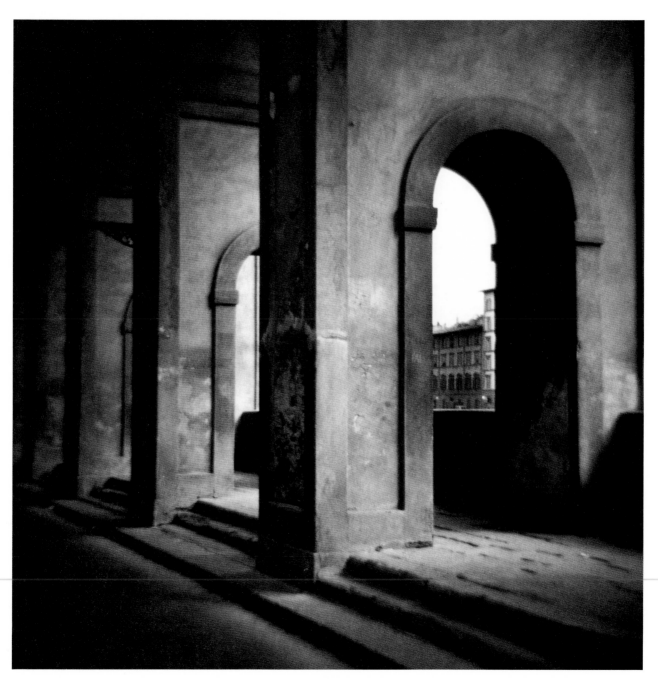

21. Archibusieri

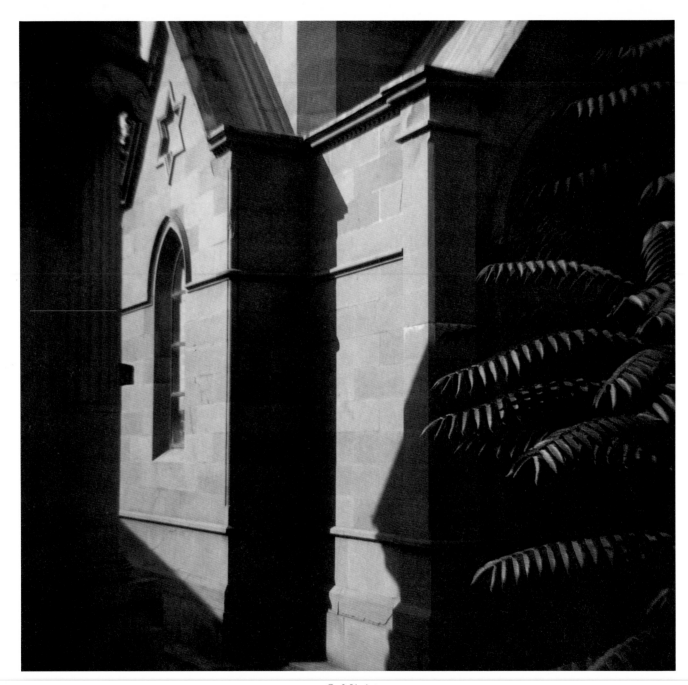

22. *S. Miniato*

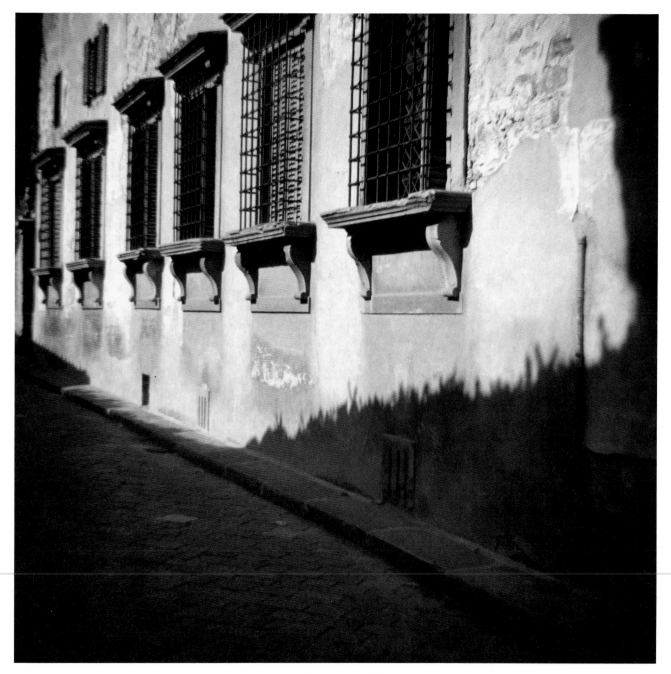

23. Via Leonardo

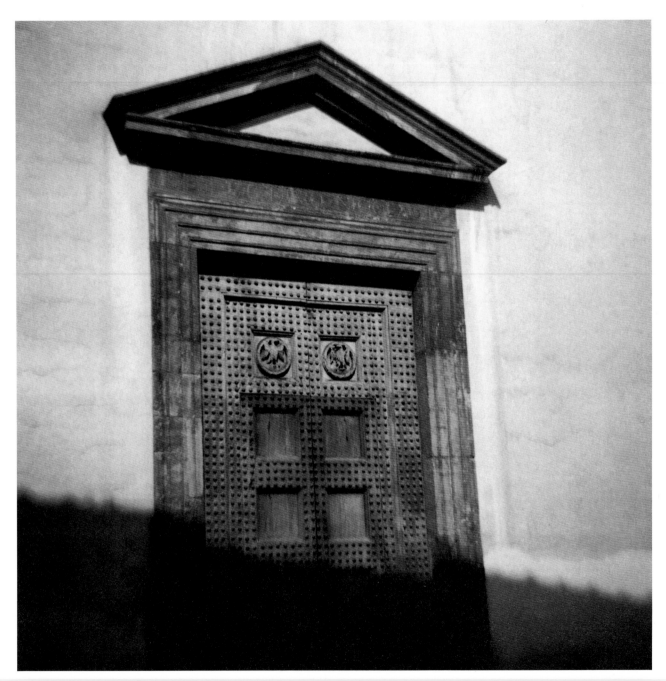

24. S. Niccolo

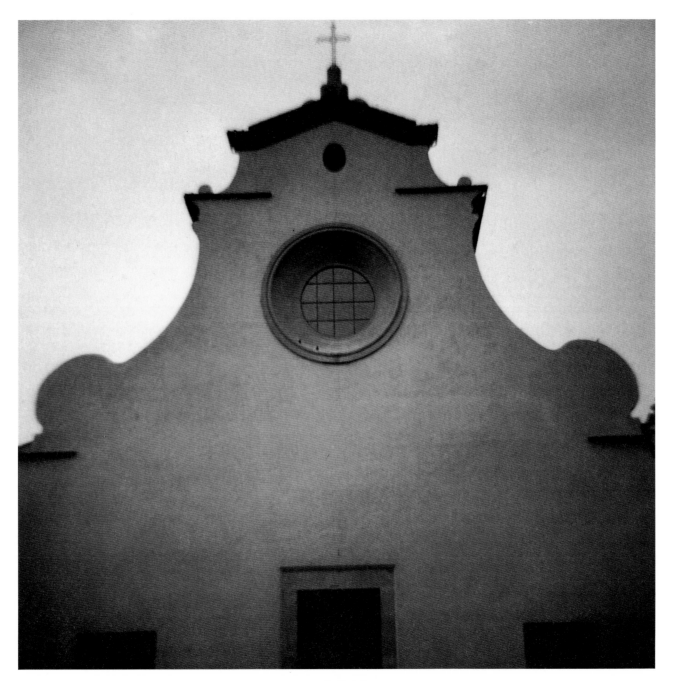

25. S. Spirito

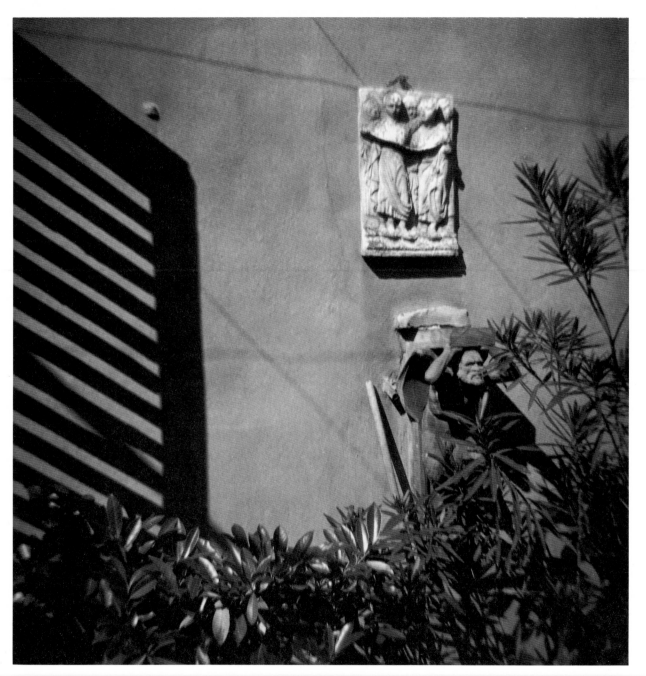

26. *Hotel Berchielli*

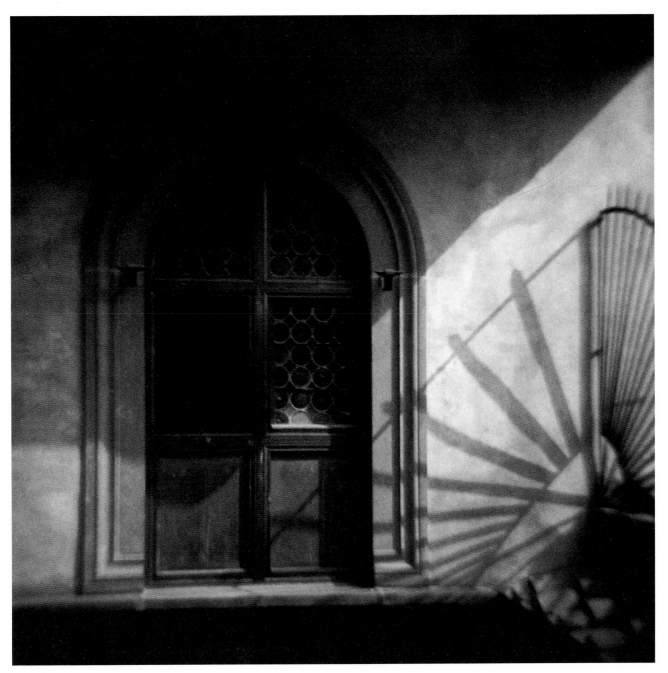

27. Horne Museum

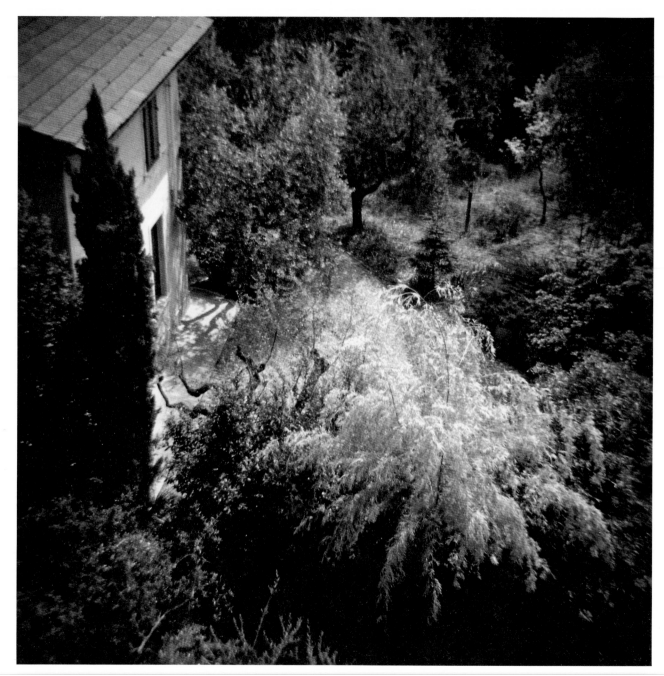

28. Villa, below Ft. Belvedere

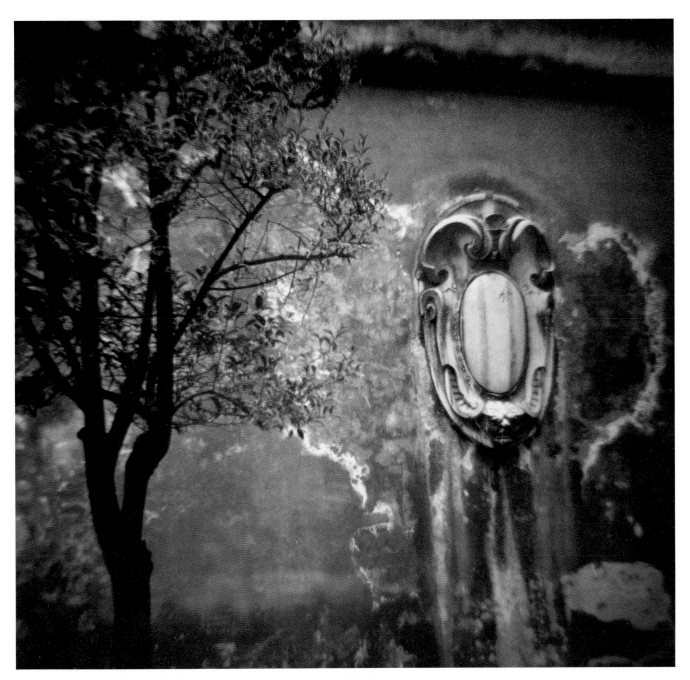

29. *Pitti Palace*

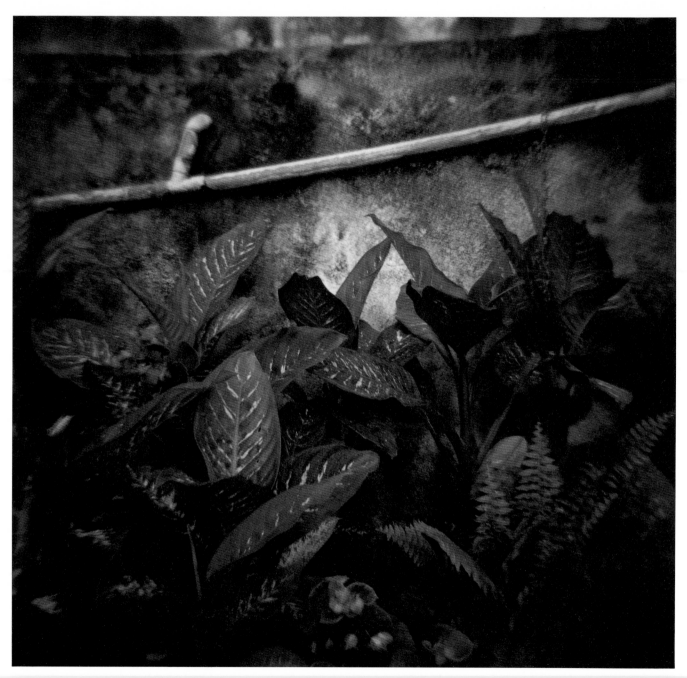

30. Greenhouse, Piazzale Michelangelo

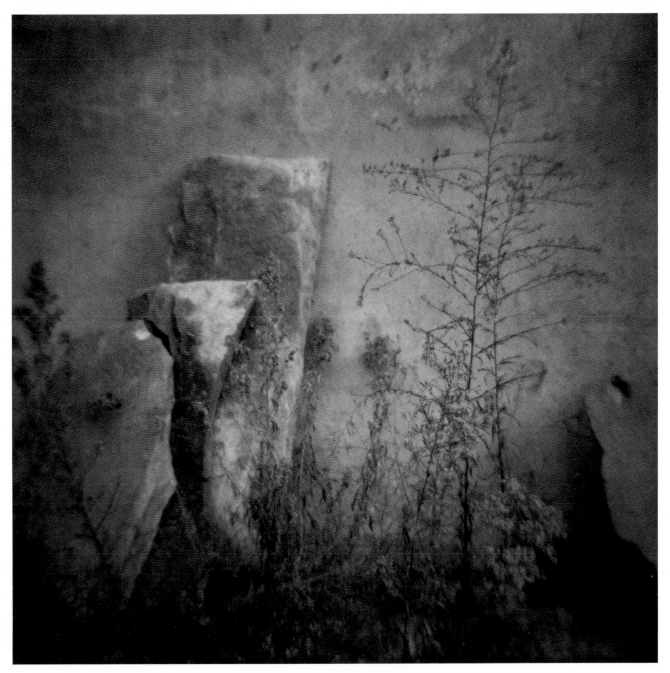

31. S. Salvatore al Monte

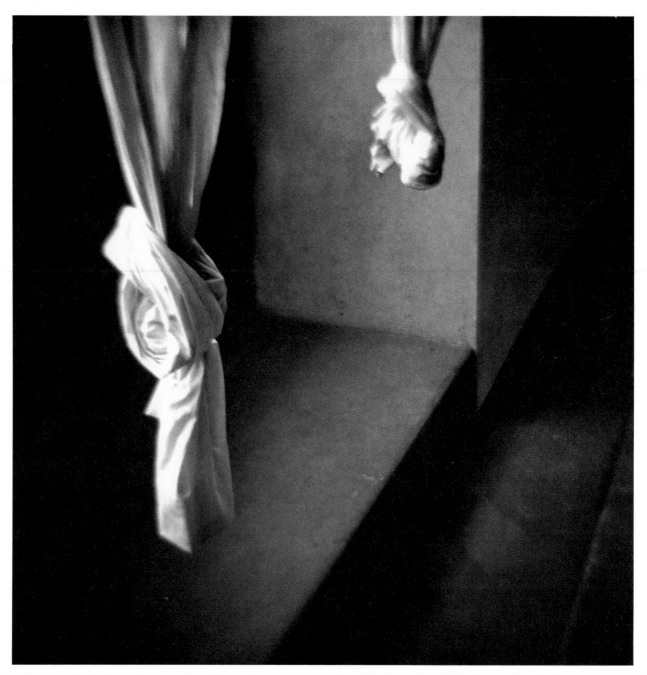

32. Orsanmichele

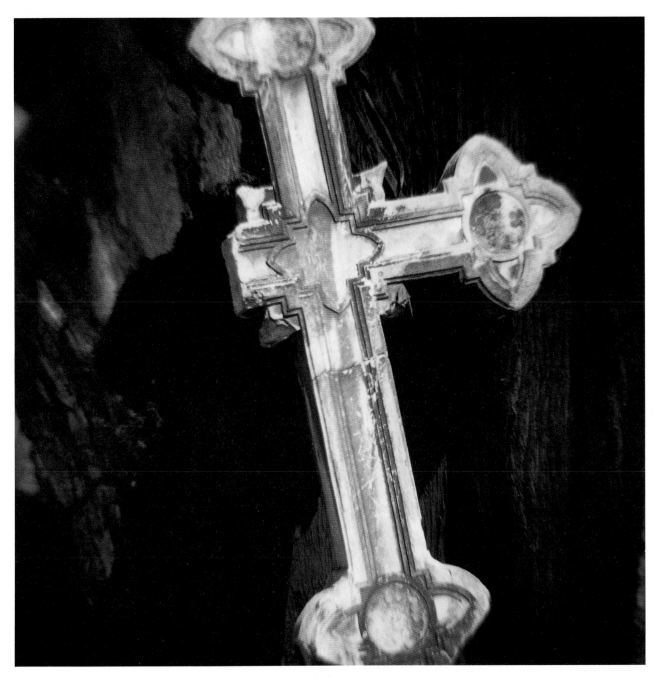

33. English Cemetery

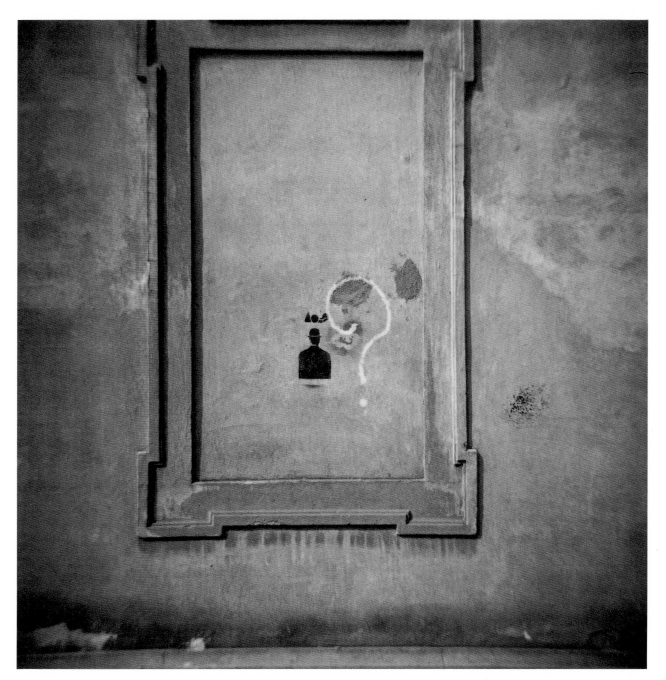

34. *Via Micheli*

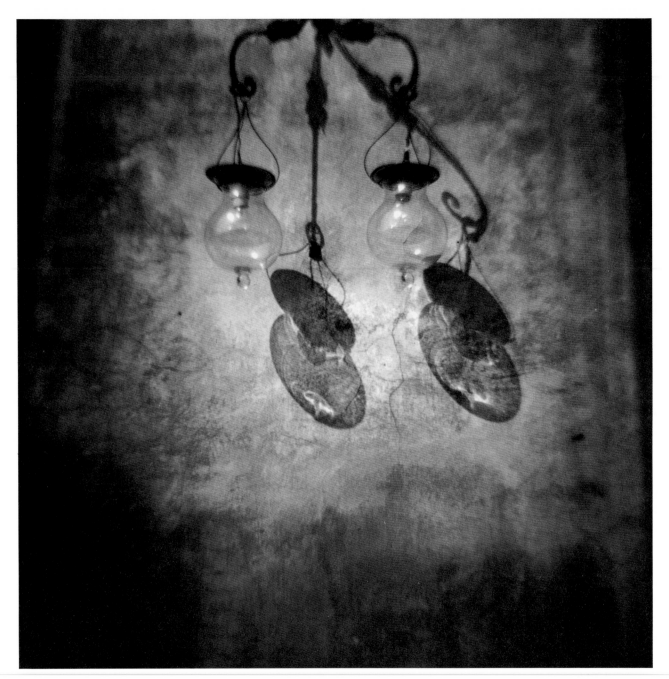

35. Lungarno Acciaiuoli

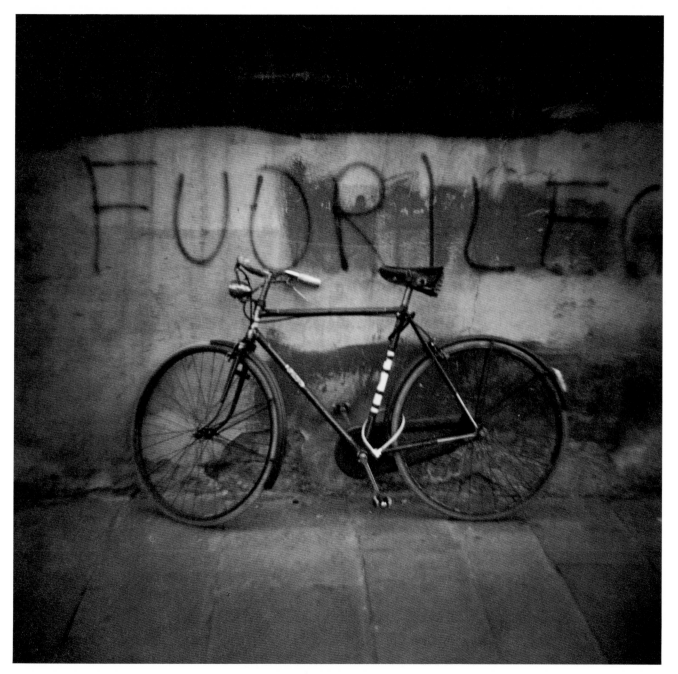

36. Oltrarno

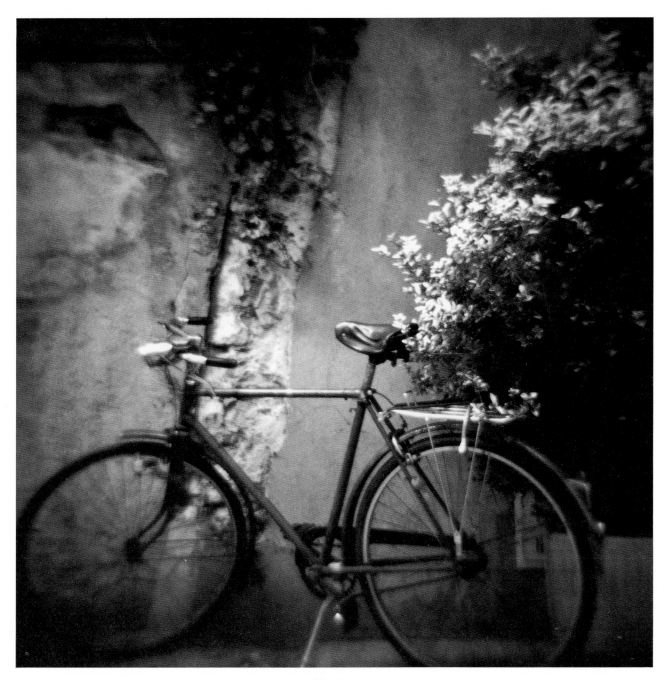

37. Via Romana

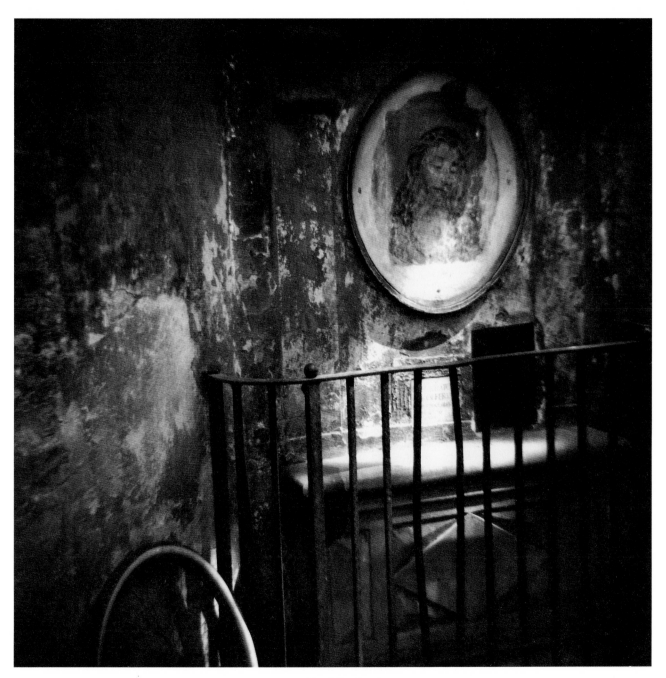

38. Via della Spada

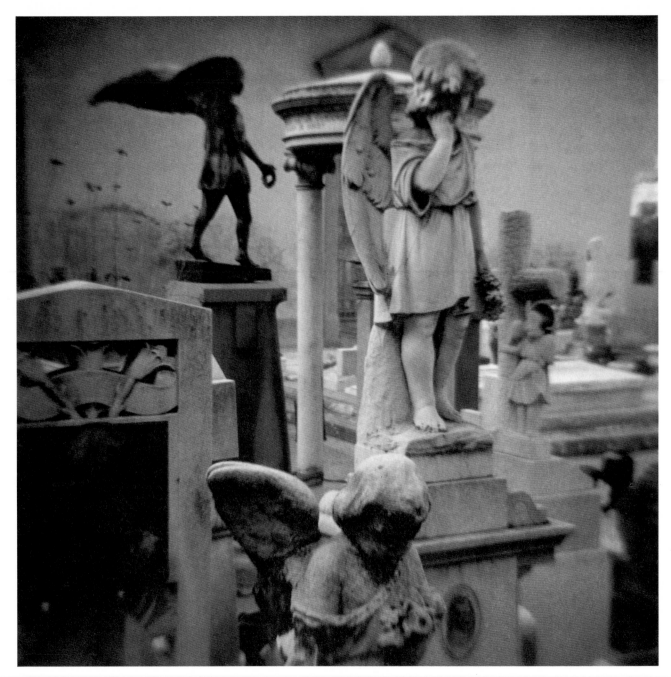

39. S. Miniato

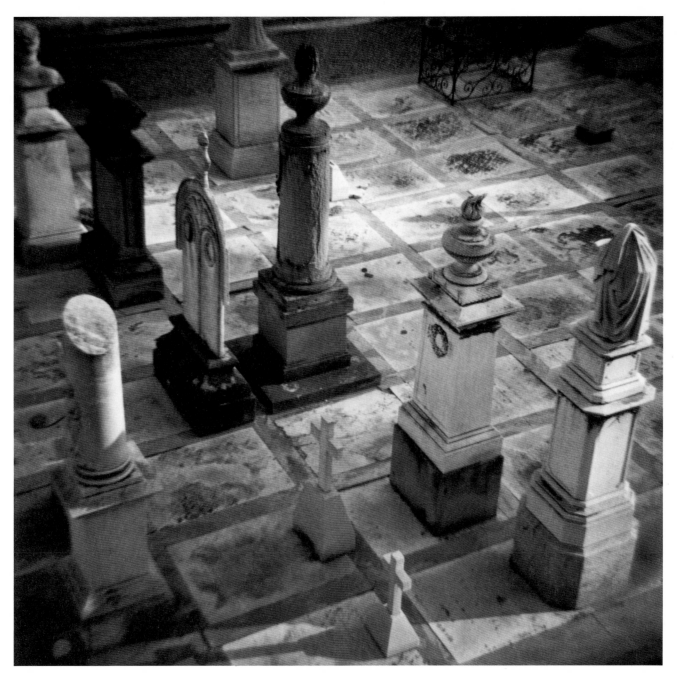

40. *S. Miniato*

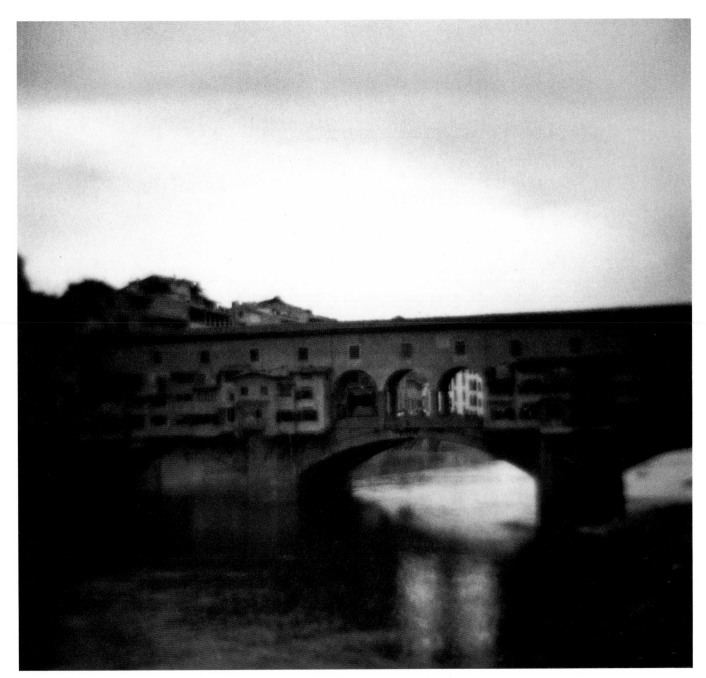

41. Ponte Vecchio

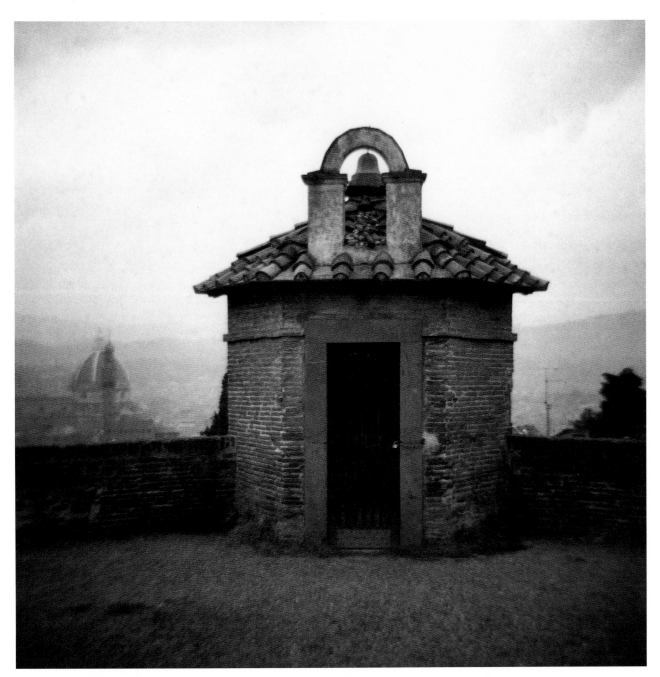

42. Ft. Belvedere

A Note on the Photographs

All of the photographs in *Angels at the Arno* were made in Florence between 1979 and 1987, and all of them using a Diana camera. I chose the Diana – whose charms and shortcomings are described in some detail by Italo Zannier in his Afterword – because its limitations would aid in rendering an intent view of the city. Diana photographs naturally tend to be centerweighted images due to the fall-off in focus and light toward their edges. I worked throughout to make photographs that are faithful to the quickened seeing I experienced on first setting foot in Florence. The film used in making these photographs was TRI-X, developed in HC110. Final prints were made on PORTRIGA-RAPID glossy-surface paper, developed in DEKTOL – occasionally in tandem with SELECTOL-SOFT – and toned in selenium.

E. L.

Afterword:
Simple Cameras and Complex Visions
BY ITALO ZANNIER

"An inexpensive camera," wrote the essayist Rodolfo Namias in 1895, "is useful only for first efforts, and soon becomes a useless object." In the decade before this, the development of the silver gelatin film process had inaugurated an international race toward the mass-marketing of photography. Relieved of the difficulties of the daguerreotype, the calotype, and the collodion processes, the photography industry rushed to market many cameras that were both simple and inexpensive. This was especially true after Kodak introduced roll film, its paperbacked strip of silver gelatin able to record one hundred round images.

A number of European companies soon joined the competition. Some manufacturers, such as Conti of Paris, began to substitute sheet metal for the traditional camera material, wood. For one thing, sheet metal made the camera smaller, lighter, and more portable. But while the metal camera offered certain advantages, as Luigi Gioppi observed in 1890, they "nonetheless had other drawbacks, such as rust." But rusty or not, the metal camera quickly won out, though the earliest hand-held cameras, available to aristocratic amateurs, continued to be made of wood for a long time. Among the earliest inexpensive cameras in Europe was the Machina Costa, produced in Turin in 1892, which, as Namias commented a few years later, "did away with complicated mechanisms." Far from becoming "a useless object," this camera captured the Italian market, at least for popular photography. In the United States, Eastman had patented its

simple camera, Kodak No. 1, in 1886 and began marketing it in 1889 with the famous slogan, "You press the button, we do the rest." The end result, the photograph, was guaranteed, but so too was its mediocrity. Still, in the innocent transgression of realistic representation, both in exaggerated perspective and in coarseness of detail, something fascinating and fresh often emerged, when compared to the higher fidelity image of a large format camera.

Over the next fifty years, the photography industry – even as it improved the mechanics and optics of cameras, as well as the sensitivity of film emulsions – increasingly targeted the amateur market. What followed was a flood of interest in travel photographs, and photography became a true mass medium.

In going from wood to metal, the industry eventually employed cast metal, as in the Leica, but for a long time cheaper cameras continued to be made of stamped sheet metal, like a Campbell soup can. Just after World War II, research intensified, and in response to the cubelike Kodak box (a plain sheet metal box, rounded at the edges and with a simple achromatic lens – "the bottom of a glass," as Italians say), European companies such as Ferrania attempted similar products. Ferrania successfully marketed the Eura, made of sheet metal and Bakelite, a forerunner of plastic that was immediately adopted by the industry for mechanical details. The most prestigious model, the Euralux, had an adjustable focus lens; but even if one forgot to adjust it, as an early encyclopedia of photography pointed out, "the photograph will be sufficiently in focus, and one has only to press the shutter."

Post-war development saw the arrival of other simple cameras, including the Zephyr, the Rondine, the Elioflex, and the Condor. With these cameras, the user was cautioned to photograph subjects only in bright sunlight. Slow-speed color

emulsions, which were beginning to appear on the market, were not recommended for use with simple cameras. Meanwhile, even amateurs with no special ambitions began to buy more expensive cameras, which soon became status symbols. However, "It's not the camera that creates the masterpiece, but the mind behind it," as a glib but insightful slogan has it – though we may wish to exclude pin-hole cameras, which offer extraordinary creative possibilities to the tenacious minimalist.

In the decade that followed World War II, as the world of amateur photography was growing larger, technological advances modified camera design and introduced new materials, especially plastic, into their fabrication. These materials offered more advantages than drawbacks, despite the resistance of the industry and of popular taste, which regarded anything made with these new artificial products as kitsch. Plastic was changing the world of objects with which we live.

In 1960, a small company in Hong Kong tried to build every part of the camera out of this new, lightweight, and above all, inexpensive material: the Great Wall Plastic Factory courageously produced a camera made completely of plastic, including the lens. This was the Diana camera, which could make sixteen exposures (4.5 cm × 4.5 cm) on the classic 120 roll film. In the same year, these cameras were introduced into the United States, selling for less than three dollars. Though the Diana was not destined to be on the market long, it quickly found passionate fans, to the point of becoming a fetish that still persists today.

The camera found its use in college art classes, pioneered by Ohio State University, despite the aberrations in its optics and the simplicity of its mechanisms (three apertures: 4.5, 6.3, 16, and three focal lengths: 4' to 6', 6' to 12', 12' to infinity – for portraits, groups, landscapes). Beginning in the early 1970s, users

discovered expressive potential in the camera, precisely in the areas where it was considered to be technically deficient: the lack of focus at the edge of the image, or the distortion of the photograph's structural lines. The Diana, a camera developed above all to be cheap, to be a child's toy, just as the Kodak Baby Brownie had once been, provided unexpected images that were impossible to obtain from any other kind of camera, least of all from technically advanced ones.

Above all, photographs made with this little camera have a strangeness, a perspective that creates an atmosphere reminiscent of police photography; they seem to be "scenes of the crime," as Walter Benjamin would say. Images taken through the plastic lens of the Diana are disquieting, mysterious, and otherworldly. Photographs of people seem ghostly; objects and architecture resemble improbable stage sets designed by a faun; a fog envelops everything in a homogeneous gray mist. It feels like returning to the origin of optics, of vision itself, to the moment when the primeval eye first opened. But there is also photography here, the whole history of photography in these Diana images, echoes from Cameron to Atget.

Eric Lindbloom has anchored his insistent eye behind the plastic viewfinder of his camera – by now as rare and fascinating as a sundial – following the thread of a fantastic tale with the theme, Angels at the Arno, and captured details of architecture, fountains, marble statues, which emerge as apparitions never before seen, phantasms from the dark, unfocused border of the photograph. Images of a moment, as fleeting as a thought, but caught by the rapid click of the Diana, which, even with her minimal technical finesse, is a thousand times more rapid than the cameras of Talbot and Daguerre. Startling in effect, precisely in the alterations they are able to produce, these images permit the gaze to contem-

plate photographic reality anew, something technically sophisticated equipment has likely made us forget.

Lindbloom has succeeded in imagining a metaphysical journey through the urban civilization of the Arno, almost inventing a parallel history, made vivid in the Diana photograph by means of the soft focus and low luminosity of the plastic lens; figures of sculptured marble, angels above all, and horses, actually seem to fly. Elsewhere his gaze falls on details of shrubbery or polished stones, wrapped in a gray that the Diana renders fleshlike, as they might be in the unworldly light after the Apocalypse.

The author is indebted to David Featherstone's essay, "Pictures Through a Plastic Lens," in the catalogue, THE DIANA SHOW, by The Friends of Photography, Carmel, California, 1980.

(Translated from the Italian by Alison A. Smith)

ANGELS AT THE ARNO

has been designed, composed, and printed at the Stamperia Valdonega of Verona under the direction of Martino Mardersteig. This book was set in Dante VAL, a special PostScript version of Monotype Dante digitized by Stamperia Valdonega from hot metal casting. The typeface was first cut in 1954 and is the last and finest design of the distinguished scholar-printer Giovanni Mardersteig. The original matrices were engraved by the great Parisian punchcutter Charles Malin in the 12–point size. The design was later made widely available on the Monotype composing machines. With its Renaissance forms and stresses, its elegant and lively italic (one that derives from the designs of Aldus Manutius), and its sparkling cutting, Dante has continued to be a favorite of many book designers. The images have been printed in 300-line screen duotone on Gardapat Matt 1.3 (1992).

LAUS DEO: MCMXCIV